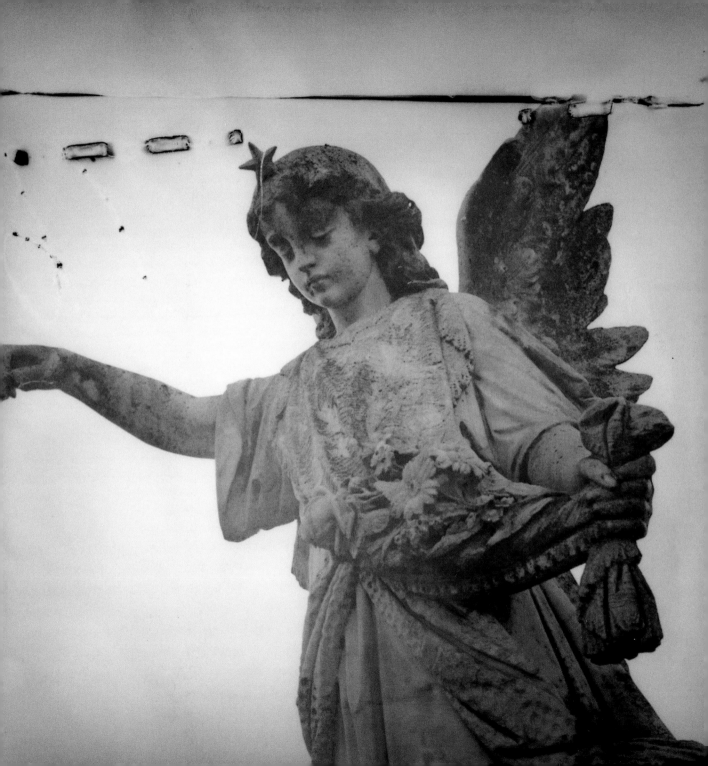

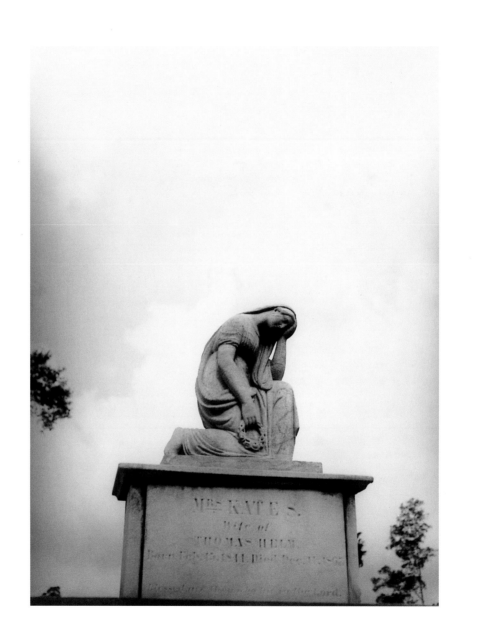

Eudora Welty

Country Churchyards

UNIVERSITY PRESS OF MISSISSIPPI / JACKSON

Publication of this book was made possible in part by

The John N. Palmer Foundation

www.upress.state.ms.us
Copyright © 2000 by University Press of Mississippi
Introduction © 2000 by Elizabeth Spencer
Photographs © 2000 by Eudora Welty

Quotations in this book are from the works of Eudora Welty.

Designed by John A. Langston
Manufactured in Hong Kong
08 07 06 05 04 03 02 01 00 4 3 2 1

CIP ÐATA APPEAR ON PAGE III

How is it that both danger and succor, both need and response, seem intimately near in little country churches?

— "Some Notes on River Country"

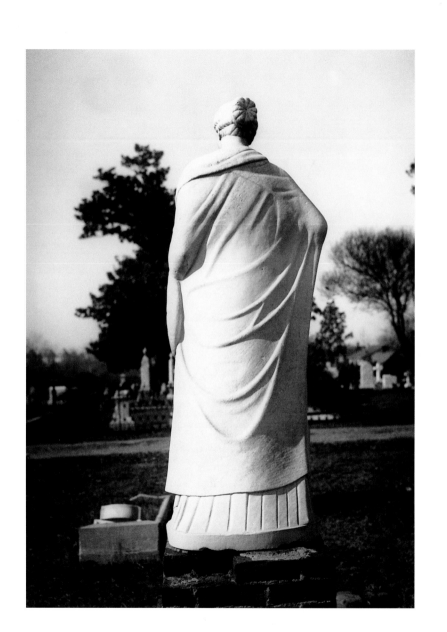

Eudora Welty is still gazing imaginatively on ordinary life. Housebound now and ninety, she sits in a lift chair, looking out the window. Beyond her, through a secondary frame made by an arching water oak and a border of azaleas, the green lawn slopes to Pinehurst Street.

Inside, although apart from it, she does not miss much of the ordinary action on the other side of the glass. A mockingbird attacking a squirrel, an invasive cat creeping across her porch, a jogger flitting past, and a young mother pushing a stroller become something special because she is their vigilant observer.

"Listen," she interrupts, "there's somebody coming in. I thought I saw a flash of turquoise blue." It's her night nurse arriving.

She has always been an interactive watcher, especially of those matters of less moment that reveal much. Her clear eyes fill quickly and then nourish her imagination with metaphors. Readers love her for delivering the obvious, but they know it's magic only after Eudora has seized on it, for her insight clinches the image with poetic grace.

This fact was confirmed as she looked through prints of a hundred photographs she snapped in Mississippi cemeteries during the 1930s and '40s.

"I always wanted to put together a book to be called *Country Churchyards,* composed of the pictures I took in cemeteries," she said.

As these photographs reveal the magic in the ordinary, they likewise document her rambles through old graveyards in river country, along the Natchez Trace, and in the small Mississippi towns near her home of Jackson. Although many readers have a notion of the real place of her fiction and her photographs, until Eudora Welty arrests it with her gaze, they likely have missed its powerful impact. When she snapped the shutter, the ordinariness of scene was transformed.

As she looked anew at her old pictures, her commentary about each proved a keen truth. A perspective on life or on death is best attained through a frame. Here are random words she spoke while reacquainting herself with the photographs one by one. Reunited with the images from six decades past, she exults in the joy of recalling her impulses. She was a loner when writing fiction, a loner when taking pictures. We rejoice in noting the lifelong art of a participant who could savor and imagine life by witnessing it.

> *I took a lot of cemetery pictures in my life. For me cemeteries had a sinister appeal somehow. I'll bet I have not seen these photographs in years. I am glad to see them again. My family were not "Old Jackson," so I had no local kin buried at Greenwood Cemetery, but I grew up near it. It was the view from the sleeping porch at our house on North Congress Street. We could look right down on it. I used to go over there and play. Of course, back then nothing was citified. There was no city look to Jackson then. It was a country town.*

Port Gibson was a wonderful cemetery town. The Presbyterian church with its golden hand at the tip of the spire is painted white now. It was reddish-pink when I took those pictures.

At Churchill everything was a unit, church and churchyard. Compared to most other cemetery people, the buried dead there were rich, Episcopalians.

Utica was a treasure trove. One morning while I was in the churchyard taking pictures, a man came out on a porch with a gun. This was on the road by the entrance, on the highway into Utica. He said, "In five minutes I'm gonna fire this pistol at you. You get out of our cemetery and don't ever come back!"

Lord, that was scary. I believed him. Wouldn't you believe something like that? He would have shot me. But it was a marvelous cemetery. There was a statue of a man in full business dress, and underneath was an inscription that said he was an honor to the earth on which he walked. So of course I took that picture.

Vicksburg had the best statuary of any. Nothing was too good for them to use. It's a dramatic cemetery, overlooking the river, craggy and ragged.

In Rocky Springs the church was of hand-baked bricks, hand-made.

Everything in Rodney is beautiful. We have a lot of Spanish moss in that part of Mississippi. Once, just briefly, it was right on the river, but then the river deserted Rodney. Back when I was there, it was a ghost town. It was known also as Rodney's Landing. At one time the only way you could get anywhere was by boat. There had been more money down there in Rodney than in some of the other places, as you can note by comparing the cemeteries. The village pet was "Mr. John Paul's Boy,"

as he was known all through Rodney. I asked him if it would be all right to take his picture, and he was pleased. I doubt if anyone had ever wanted his picture. He must have been sixty at least. And he never did button his pants.*

The situation of Rodney, the geography, was familiar to me. It was an old part of Mississippi, an old settlement. All the river towns had a style of their own, including the fact of Roman Catholicism. That's where a lot of the style came from. The Catholic church looks like a little doll-house.

Mississippi had no art except in cemeteries. I like the tombstones showing children asleep in seashells. I love this sleeping child who is cracked from top to bottom. A broken chain and a hand removing one link—I like this kind of rope, a rope of years. And two joined hands, those are of part-ing, at least that's how I interpret it. There were lots of baskets that spilled out their flowers. Look at the lambs and their kinky curls. I like this one, the willow tree that snapped off in two. I love the fam-ily beneath the willow tree. They're grieving for their lost father and husband. Poor little things, they're just knee-high. All these little bitty things, weeping at her knee. On the gate at the Port Gibson ceme-tery the figures are in grief. They're weeping for all the sadness within. People planted Easter lilies around their relatives. I suppose the choice of plantings was entirely up to the individual. A lot of hardy flowers that could withstand the freezes, and plenty of bulbs in the springtime. These look like little roses.

And here too among my pictures are the gravediggers. I'm afraid they're going to be friends of mine. How did I feel as a stranger taking pictures in small-town cemeteries? For the most part, they

* Called "Mr. John David's boy" in "Some Notes on River Country"

were perfectly wide open to that. There were people visiting the graves of their family in a familiar fashion all the time. I discovered all these things myself in my travels. Local people didn't usually pay attention to anybody like me who happened to be wandering through. I didn't cause any stir by taking pictures.

Hunter Cole

SUMMER 1999

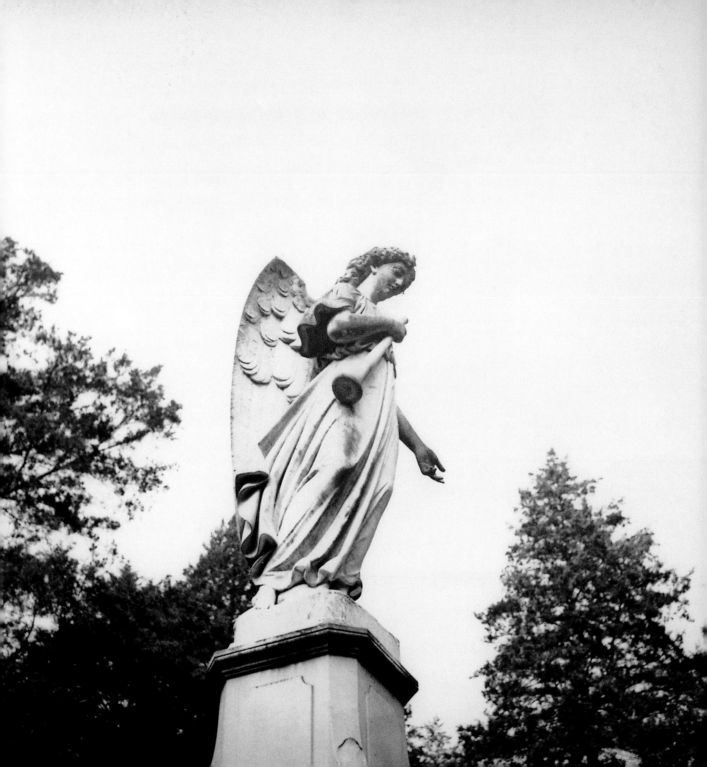

An Abundance of Angels

Elizabeth Spencer

WHAT HAVE WE HERE? CEMETERIES?
Let's go through those iron gates and look.

What's to be found in Mississippi cemeteries, most of them in this book put there during the last century? The aggregate seems a riot of expressions in defiance of the brutal ending that death brings to us all. Angels, cherubs, children, sheep, broken chains, weeping willows, portrait monuments, lyres, wreaths, pointing hands—all were decided on at that distant time, commanded to be done and lovingly placed. And so we find them lovingly recorded here. But time sets in even with these stones; moss and vines too often cover them. Upkeep is required, but many break and moulder anyway. With such a collection as this we can see what they were at the time—possibly during the 1930s—that they posed to be photographed. A search for them now, especially in lost towns like Rodney, might show that many have decayed or vanished.

From Eudora Welty, a writer so close to the very heartbeat of living and to life's most revealing moments, this large collection of cemetery photos may surprise us. Yet all her art, as she has described it, whether in photography or fiction, is an effort to rescue life from

oblivion. So these sculptures and inscriptions may be seen as family efforts to show that very thing, to hold off oblivion a while longer from the lives they commemorate.

Looking back, I find that my own Mississippi childhood memories, not so much later than Welty's own, have a lot to do with burying places.

"Where do you bury?"

That question often came up, especially among country folks, and weren't we Mississippians all, in those days, country folks?

The question is not a simple one; it contains many levels of meaning. Among them: Where are you from? Who are you kin to? Do you still call that place home? Do you return there for your family funerals? Or have you lived in this place long enough to call it, firmly and finally, your home? If so, the answer to "Where do you bury?" would be "Why, right here, of course," in Carrollton, or Jackson, or Holly Springs, or Ecru, or Port Gibson, or Winona, or Crystal Springs.

But then, too, the answer might be a distant place, according to a wish of the deceased, or of the family. Somebody might want to return to a town in Tennessee or Georgia, or maybe to some small hamlet in Mississippi, moved away from long ago, but never quite left behind. There, waiting patiently, a quiet spot surrounded by an iron fence, entered by an ornamental wrought-iron gate, dripping grey with Spanish moss, may be knowing in its silence that it is not forgotten any more than it forgot. Such places are for memory working both ways—within the place, within the heart.

Isn't it clear that the question "Where do you bury?" is loaded with meaning.

In Carrollton, where I grew up, Evergreen Cemetery was set out from the old town of Carrollton, very near the newer town of North Carrollton. There would be a reason why, but I never asked it. It remains a lovely, quiet place, kept in the days I best remember by an aging black man, meticulous mower and edger.

A gentleman I knew in Oxford, Mississippi, when I taught at the university, a certain Mr. Trotter, used to greet me with a wild whoop of laughter. "Carrollton! Such a nice cemetery! Town's falling apart but you sure look after the dead ones!"

My own visits to the cemetery were mainly the sad occasions of family funerals, but I also remember going there with my mother and some ladies who may have wished to leave flowers or to see a headstone installed. Being tom-boyish in my foolish years, I once went frolicking over graves and leaping around on tombstones until my mother sharply reminded me to be more reverent. "Never step on a grave," she sternly instructed. "You must never do that." It seemed as firmly believed in as a point in manners—you must; you must not. A friend has related that Eudora Welty said she also played about on gravestones as a child, her first home in Jackson being adjacent to a cemetery. It must be that all children, given the chance, would like to sport around like that in cemeteries.

A famous English poem, Thomas Gray's "Elegy Written in a Country Churchyard," speaks of "the short and simple annals of the poor." But the annals of Mississippi's deceased, well-off or poor, could never be called either short or simple, as witness the many fine explorations of their intricate worlds as given us by Eudora Welty's fiction, William Faulkner's also, and any number of others.

We had our churchyard cemeteries, too, pre-dating the larger ones laid out for the whole

town. They existed, of course, throughout the nation, especially, one would think, in the South. Many an old church keeps watch over its departed members yet.

And before churchyards, there were home cemeteries, still to be found on the back properties of some old houses. Even after the house is gone, the graves and their stones will remain. Some are moved to avoid a highway running over mouldering remains beneath that sort of mounded earth one is not to walk on. In and around Carrollton these are to be found, stones dating back to the early eighteenth century, before the Indians left. The dates are of interest, the inscriptions getting harder to read. Some of the photographs here, marked simply "Natchez Trace area," or "Rocky Springs" seem to be home burial plots, long preserved.

It is principally tomb sculpture that drew Eudora Welty's attention. Elaborate tombs were usually the idea a prominent family had about themselves. There rises up a central slab calling out the family name; the individuals with their separate headstones cluster around. But nothing is ever enough when death has opened a door, then shut it irrevocably, forever. Finalities break the heart—how does the heart cry out?

The monuments, so liberally represented among these pictures, are an answer. Eudora Welty seemed especially drawn to angels, though maybe they would have been hard to miss, as Mississippi families did favor putting them on gravestones in all their winged splendor. We must stop and think about this, remembering sentiments and expressions linked to the nineteenth century. That time was filled with the phrases begging to be engraved in stone and also with the images longing to speak.

If there is anything Mississippians knew well, it was the Bible. Who are these creatures with their lovely classic features, their noble wings? The underlying thought may be that to die is to become one, sprouting wings and flying skyward. It's an easy image, but has no basis, I think, in scripture. More appropriate is the real role given to angels. They are visitors. They are sent on missions. I think the belief represented by these stone figures is of an angel taking someone away to an unknown place, which the angel came from and knows about already. What better company for the journey?

But Eudora Welty found many other monuments worth photographing, too. Among the most touching is a basketful of flowers, overturned, the flowers spilling out. Could this be the tomb of a child? And some figures, not angelic, are simply women in long graceful robes, bent in attitudes of grief. One wonders if the sculptors of these figures were perhaps the same one or two artists working in a variety of places, because figures, faces, and attitudes so often resemble each other. Surely they were of local workmanship, not ordered from "off" like the familiar Confederate soldier rising above every county courthouse, all of which originated, we are told, in Vermont.

There are the inscriptions, too: "Come Ye Blessed" cries a tomb to a McDowell. . . . "He was an Honor to the Earth" is proudly chiseled to describe a gentleman who stands life-size, hand in pocket, hat in hand. "True to the Public Trust" proclaims another inscription, exhibited just below a portrait in stone of the worthy man who was; in fact, he is holding it himself. One inscription I found in a small Carroll County graveyard was on a child's little tomb, his age in months only, his stone reading: "He budded on earth to bloom in

heaven." There is a similar one in the collection here: "An opening violet, little darling / You left us to bloom in paradise."

One is bound to wonder what Eudora Welty herself thought about what she was so skillfully copying on film? She, of course, as we all know, has left us myriads of photos, largely of Mississippi scenes and people during the Depression years, a record which springs to life again when we view them. Perhaps these of burying places were meant to mingle with the rest, not to find themselves in a separate collection which will inevitably raise the question of the photographer's viewpoint and meaning.

Her fiction gives us many clues to what her attitude was, for there are many closely observed passages about death and burying.

One thing that speaks out plainly is the relation of death and the funeral with the family. Even in the hilarious funeral described by Edna Earle Ponder in *The Ponder Heart*, it is the Peacock family she is observing as they meet to bury Bonnie Dee, whom Uncle Daniel Ponder tickled to death during a thunderstorm.

To get to the funeral Edna Earle and Uncle Daniel have to find a country house out from Clay. The Peacocks, Bonnie Dee's family, "live out from it, but trade there, and, as they said, bury there."

> People, people, people, flowers, flowers, flowers, and the shades hauled down and the electricity burning itself up, and two preachers both red-headed; but mainly I felt there were Peacocks. Mrs. Peacock was big and fat as a row of pigs, and wore tennis shoes to her daughter's funeral—I guess she couldn't help it. . . .

Bonnie Dee was holding a magnolia a little too big for her size. . . . They had her in a Sunday-go-to-meeting dress, old-timey looking and too big for her—never washed or worn, just waved: white. She wouldn't have known herself in it. . . .

During the service, half the Peacocks—the girls—were still as mice, but the boys, some of them grown men, were all collected out on the porch. Do you know what they did out there, on the other side of the wall from us? Bawled. Howled. Not that they ever did a thing for their sister in life, very likely, or even came to see her, but now they decided to let forth. . . .

But then we remember the grievously sad funeral of Laurel Hand's father in *The Optimist's Daughter,* arranged by her stepmother to take place in the "new cemetery," near the highway.

Dr. Bolt [the minister] assumed position and pronounced the words. Again Laurel failed to hear what came from his lips. . . . Sounds from the highway rolled in upon her with the rise and fall of eternal ocean waves. They were as deafening as grief. Windshields flashed into her eyes like lights through tears. . . .

Here in Laurel's vision we find real grief, if not in Edna Earle's. And let us remember Miss Eckhart in *The Golden Apples* trying to cast herself bodily into the grave with Mr. Sissum. Let's think of Miss Snowdie's funeral in the same book, bringing out the whole of Morgana.

On one could go with passage after passage, but what seems to speak most plainly to me is Eudora Welty's vision of death as a part of life. It must find its ceremony within fam-

ily and community, and its symbols, beautifully displayed here, arise out of the beliefs and feelings of shared love.

Further than that this artist will not go. She is not, as she has told us in *One Writer's Beginnings*, a "believer" in the traditional sense of the word. What comes through to us here and in her fiction is her sense of reverence for life's mysteries, death being one of those. But sometimes, even in the grim face of it, we can't help but laugh. How not to when we see the little winged children racing about with wreaths on a matched pair of Jackson tombs, or a whole sheep, lying atop another, looking wildly astonished to be there?

Unlike skipping about on graves, this thread of laughter is no part of irreverence. Anything Eudora Welty put her hand to, had laughter lurking somewhere, ready to break in. And that, too, she viewed as part of life.

Country Churchyards

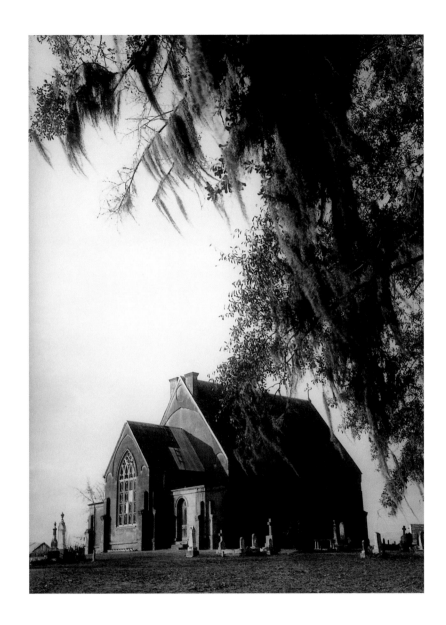

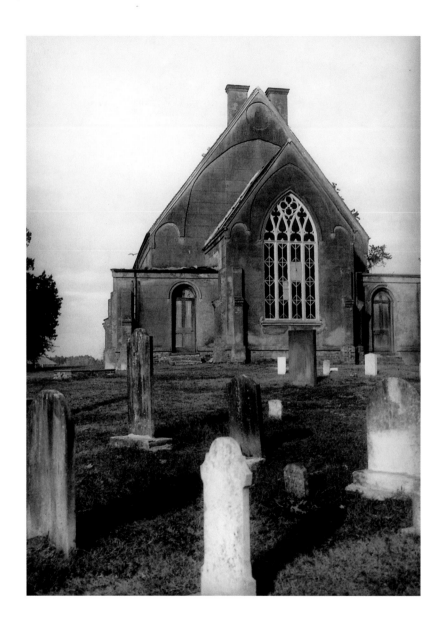

An army of tablets, some black as slate, marked half a hill-load
of husbands and wives buried close together.

—Losing Battles

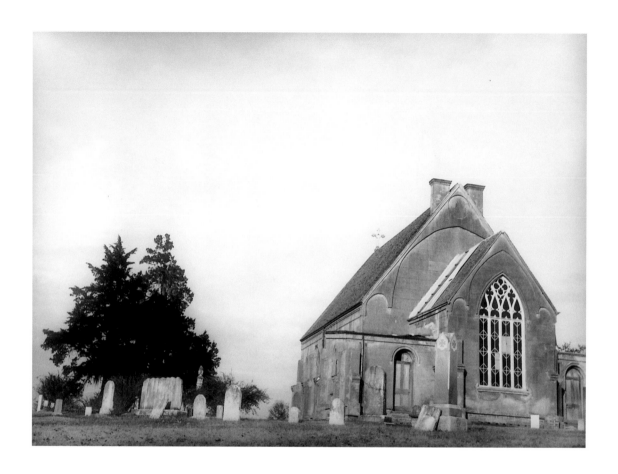

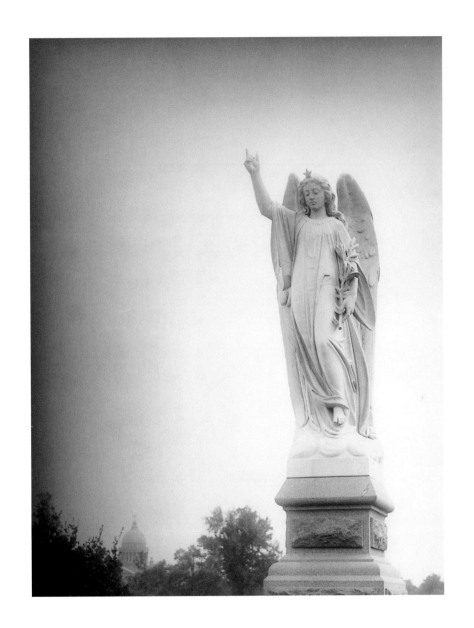

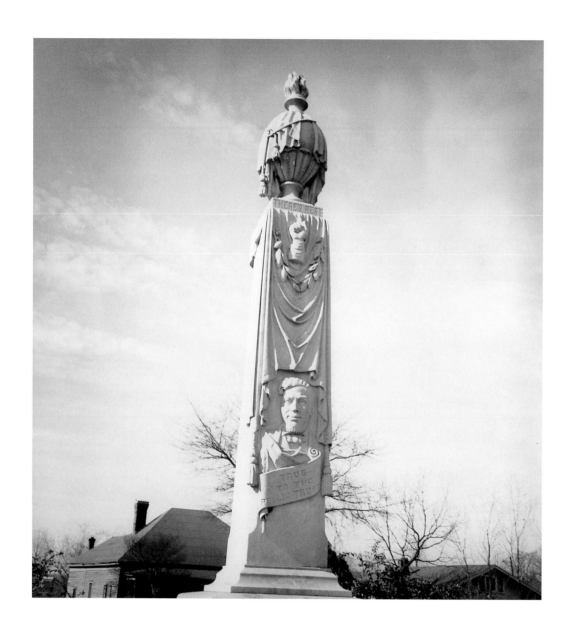

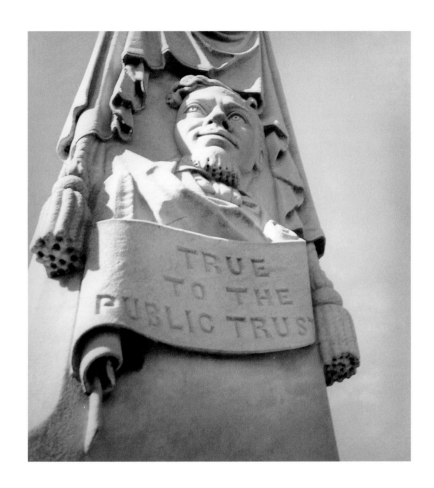

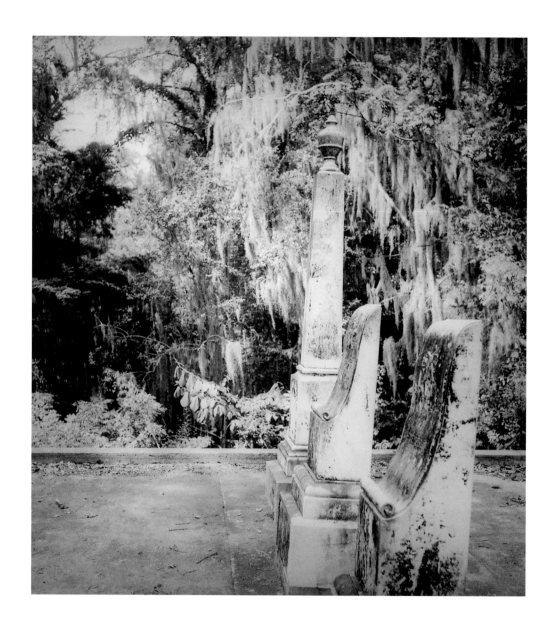

Everywhere there, the hanging moss and the upthrust stones were in that strange graveyard shade where, by the light they give, the moss seems made of stone, and the stone of moss.

—"At the Landing"

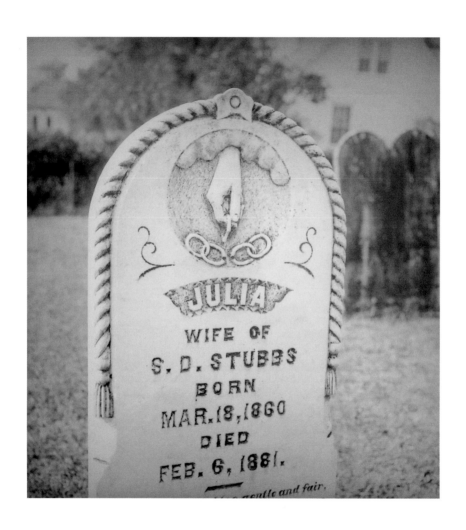

JULIA

WIFE OF
S. D. STUBBS
BORN
MAR. 18, 1860
DIED
FEB. 6, 1881.

gentle and fair,

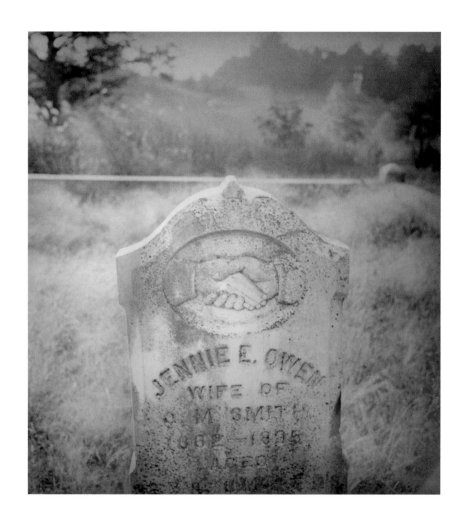

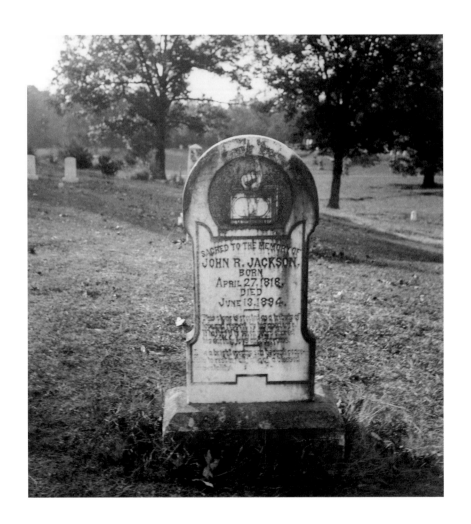

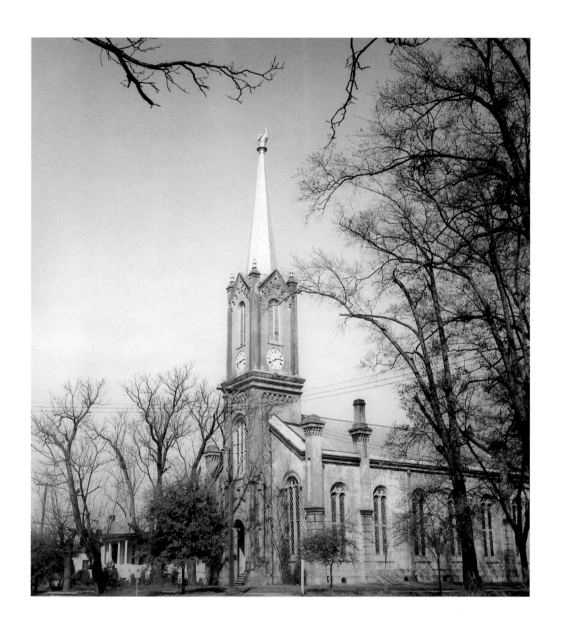

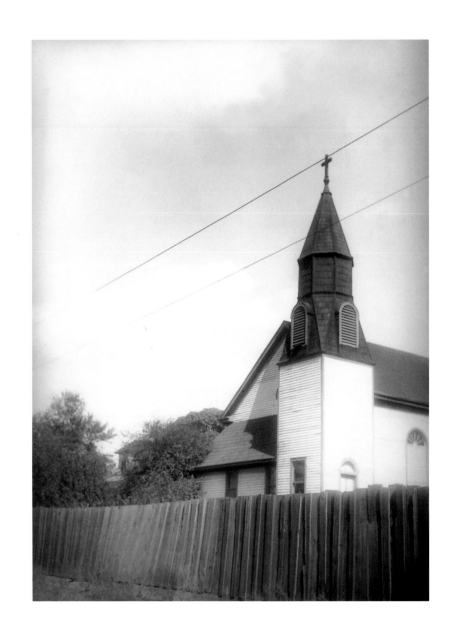

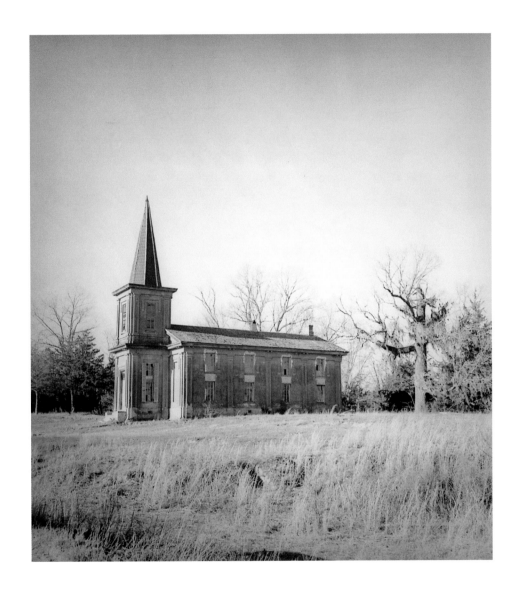

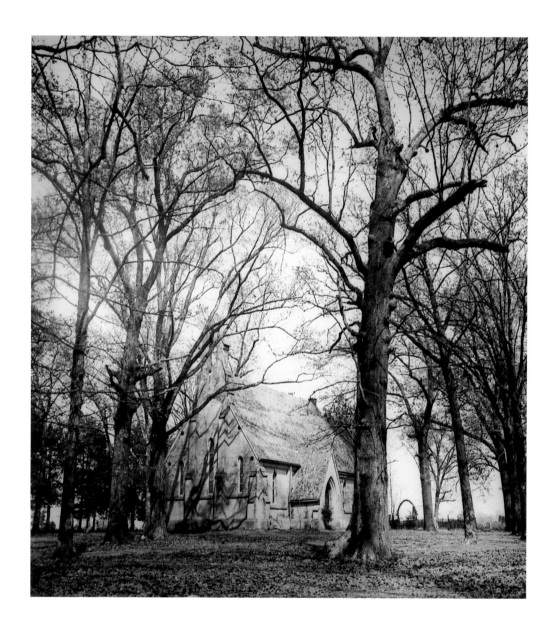

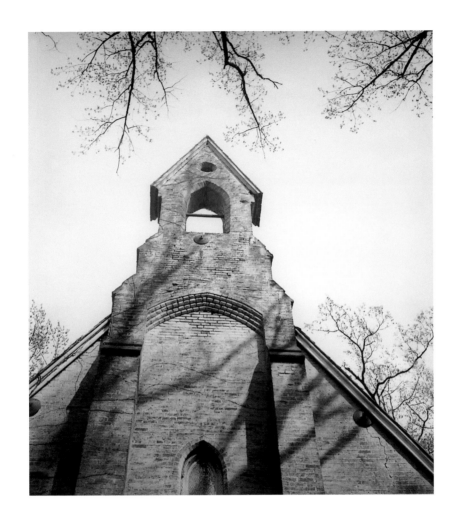

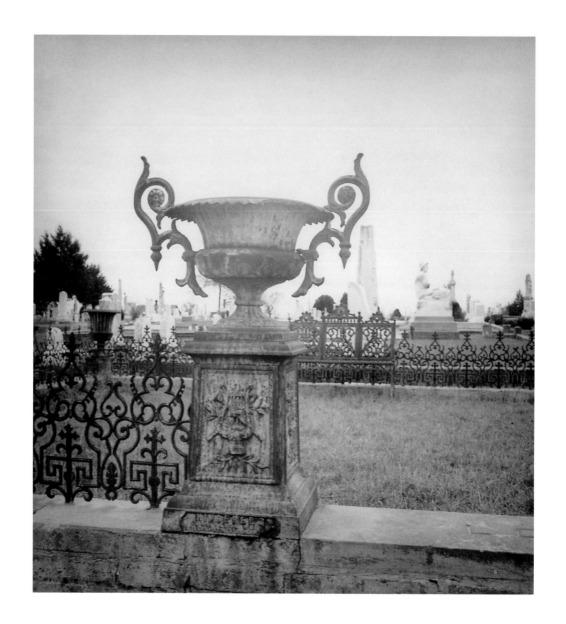

There was a ringing for each car as it struck its wheels on the cattleguard and rode up into the cemetery. The procession passed between ironwork gates whose kneeling angels and looping vines shone black as licorice. The top of the hill ahead was crowded with winged angels and life-sized effigies of bygone citizens in old-fashioned dress, standing as if by count among the columns and shafts and conifers like a familiar set of passengers collected on deck of a ship, on which they all knew each other—bona-fide members of a small local excursion, embarked on a voyage that is always returning in dreams.

—The Optimist's Daughter

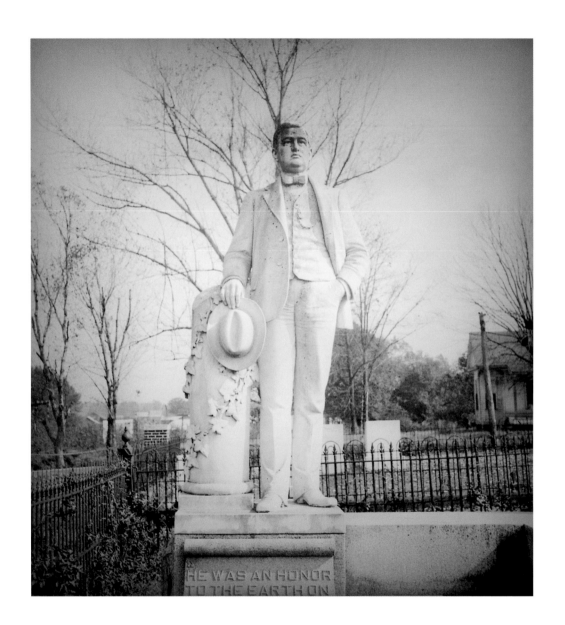

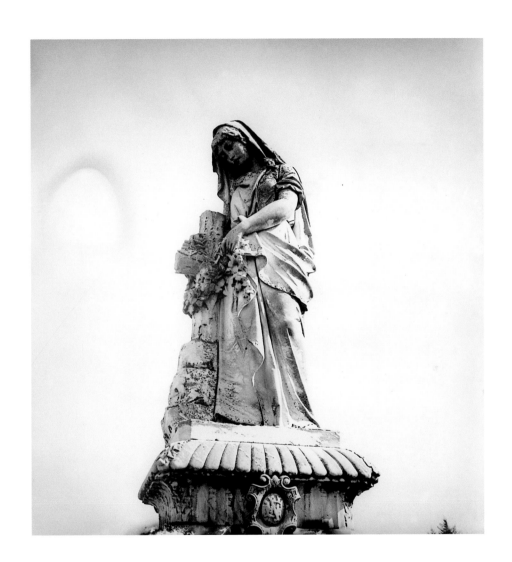

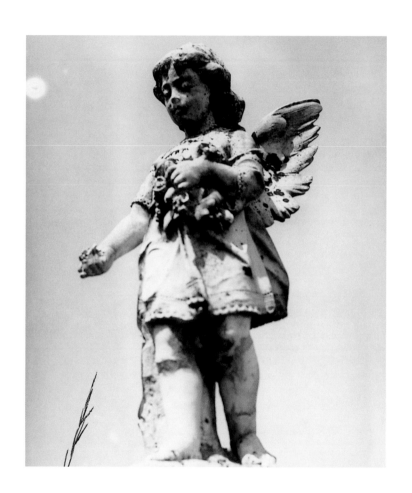

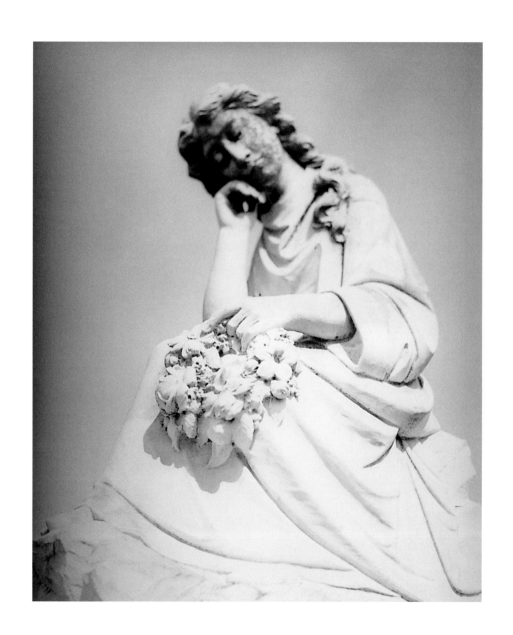

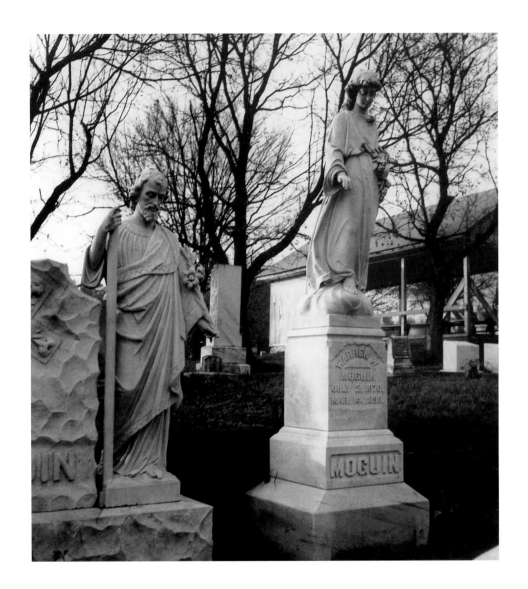

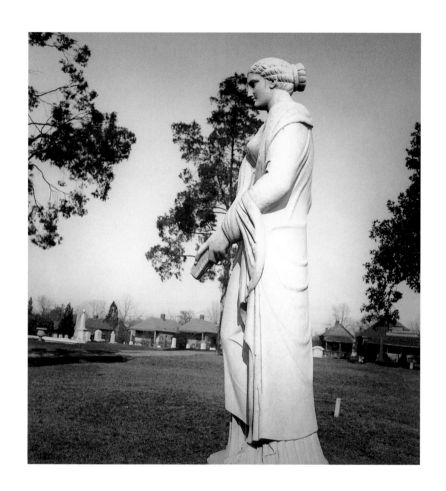

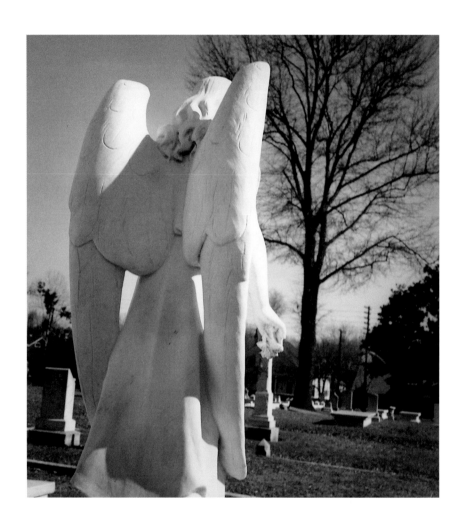

They had to drive the length of Morgana to the cemetery. It was spacious and quiet within, once they rolled over the cattle-guard; yet wherever Virgie looked from the Stark's car window, she seemed to see the same gravestones again, Mr. Comus Stark, old Mr. Tim Carmichael, Mr. Tertius Morgan, like the repeating towers in the Vicksburg park. Twice she thought she saw Mr. Sissum's grave, the same stone pulled down by the same vines—the grave into which Miss Eckhart, her old piano teacher whom she had hated, tried to throw herself on the day of his funeral. And more than once she looked for the squat, dark stone that marked Miss Eckhart's own grave; it would turn itself from them, as she'd seen it do before, when they wound near and passed. And a seated angel, first visible from behind with the stone hair spread on the shoulders, turned up later from the side, further away, showing the steep wings.

— "The Wanderers"

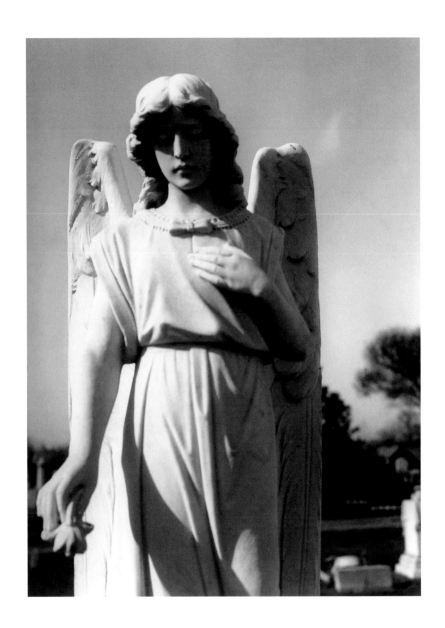

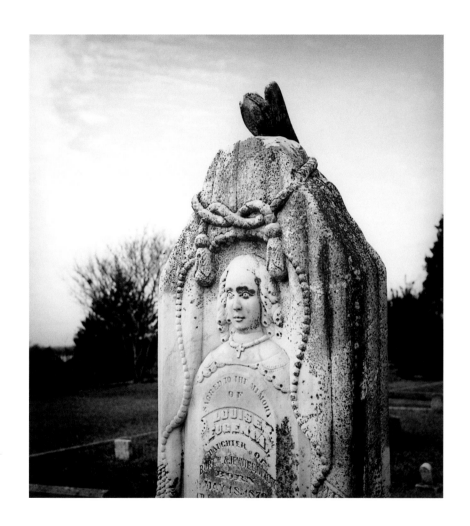

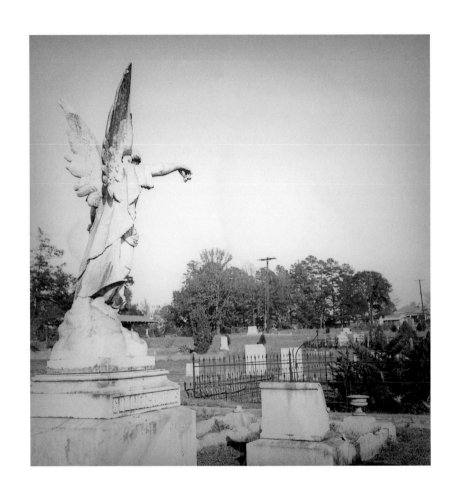

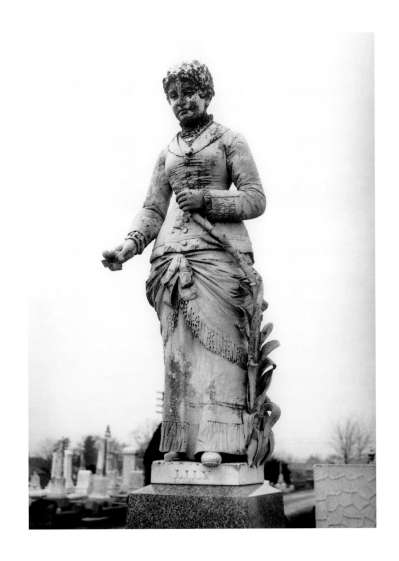

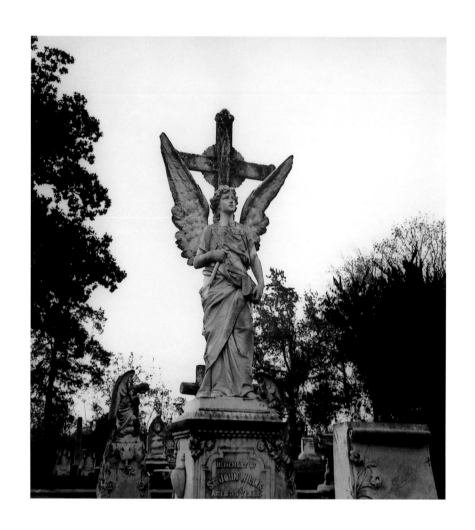

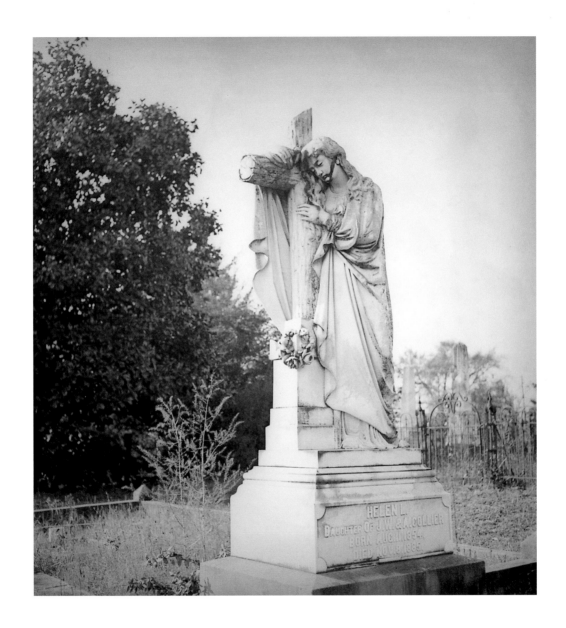

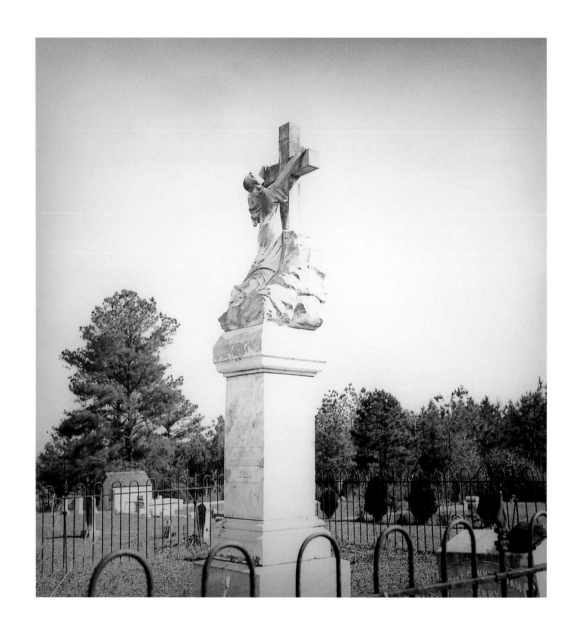

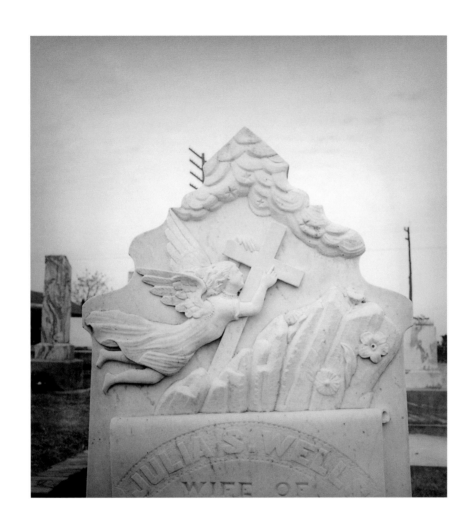

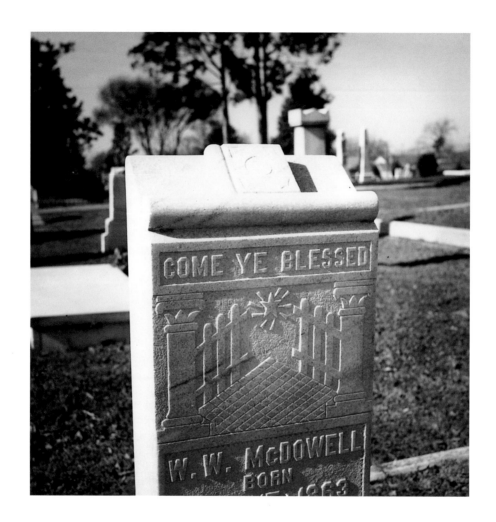

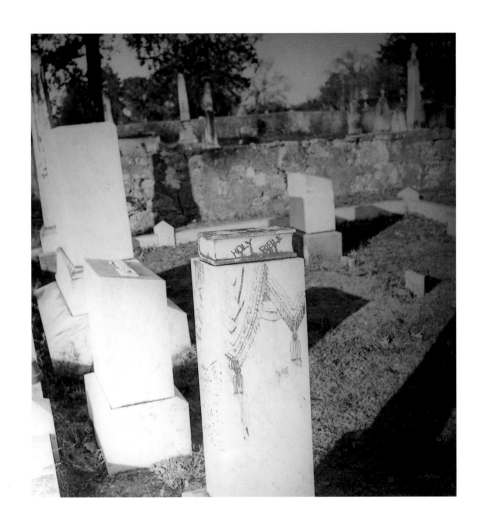

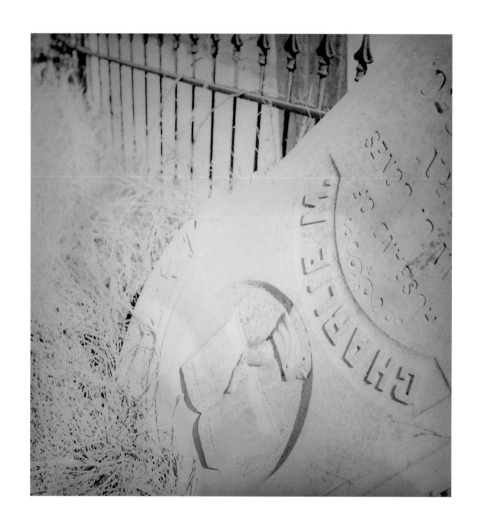

61

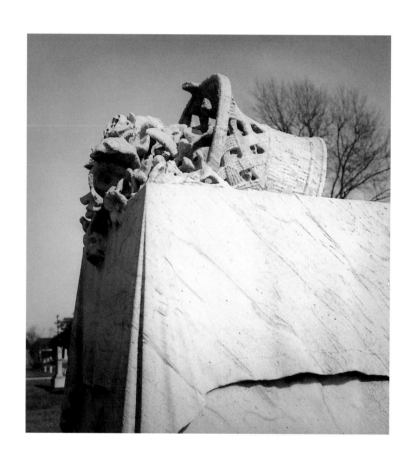

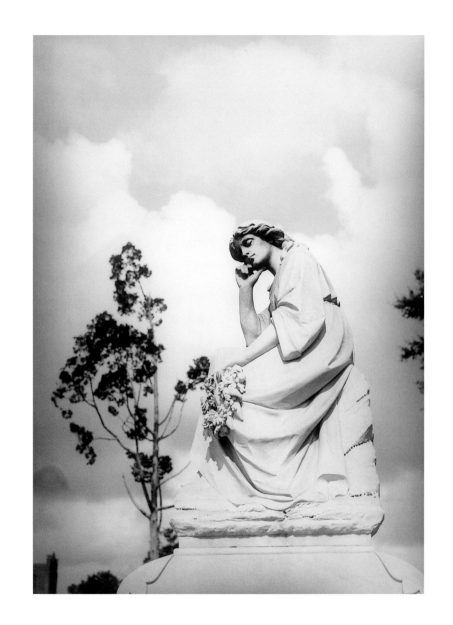

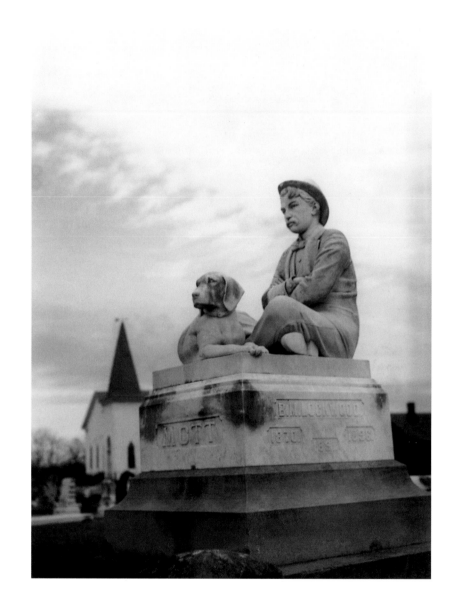

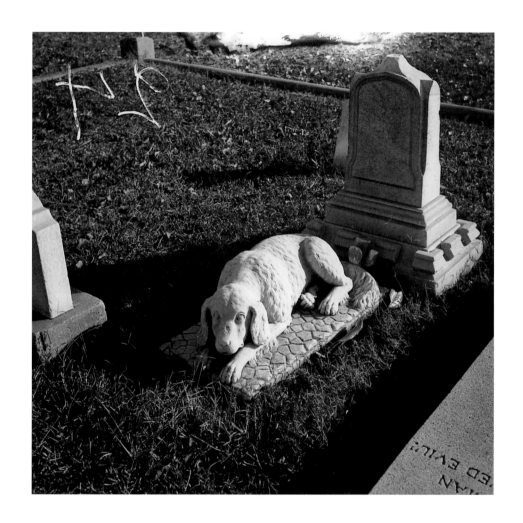

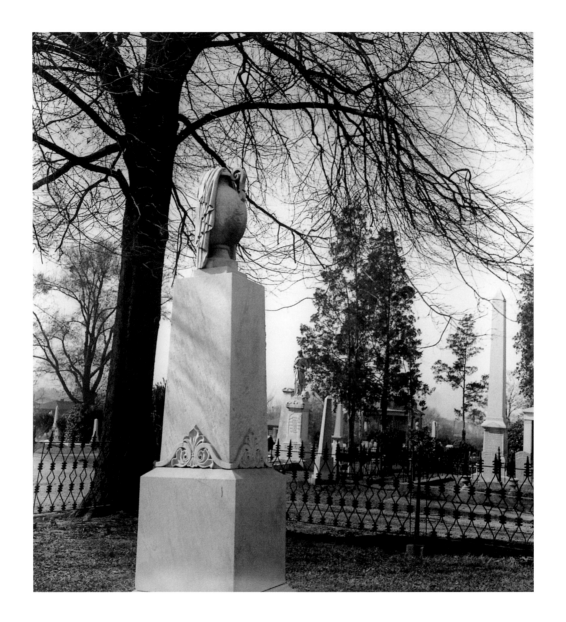

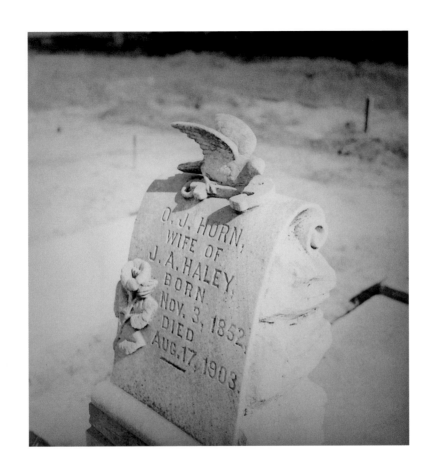

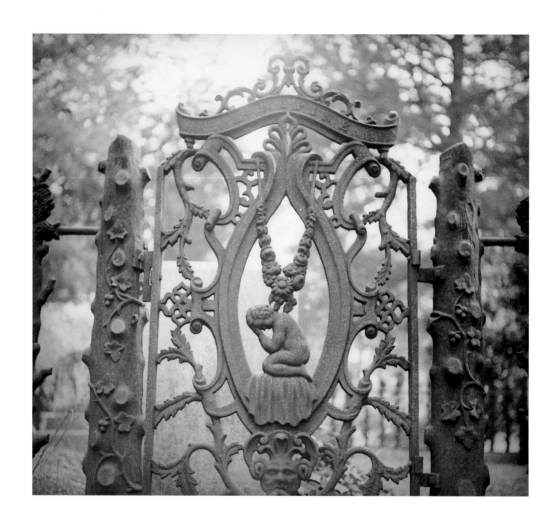

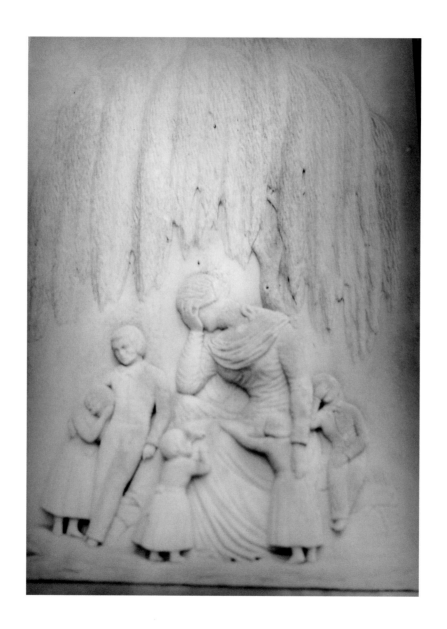

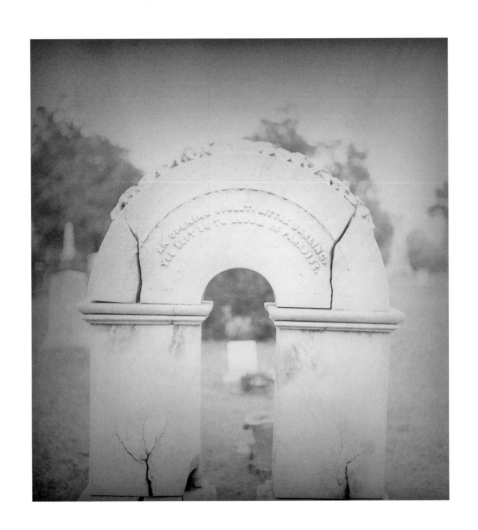

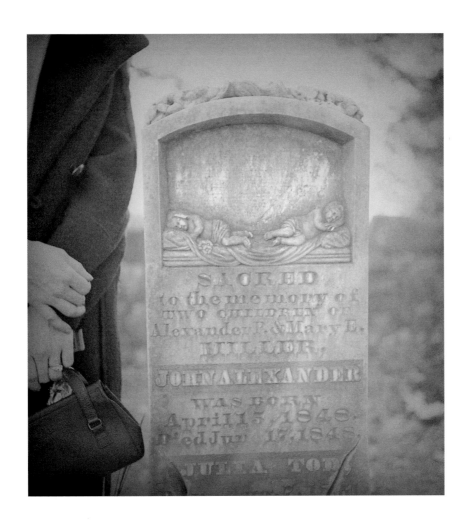

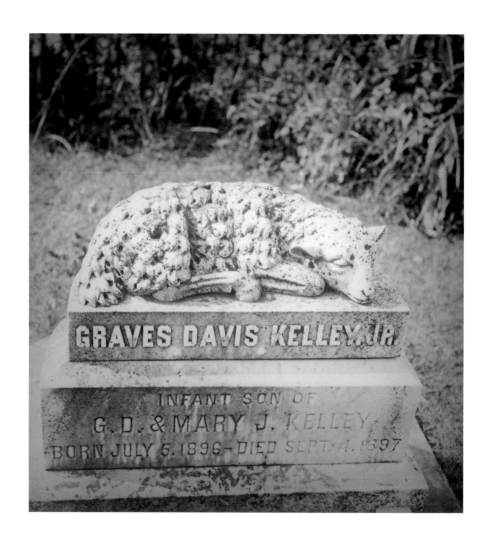

GRAVES DAVIS KELLEY,JR

INFANT SON OF
G.D. & MARY J. KELLEY
BORN JULY 5,1896–DIED SEPT. 4, 1897

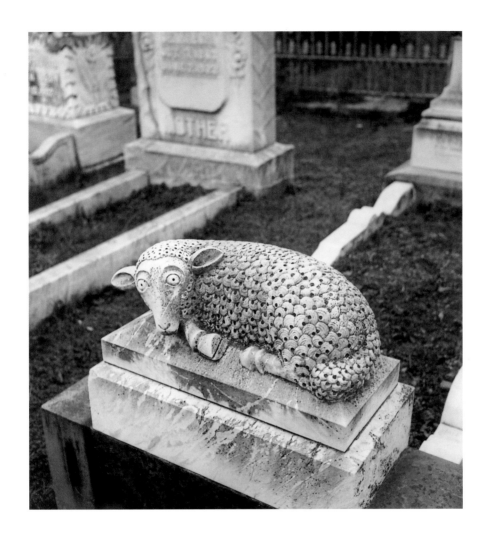

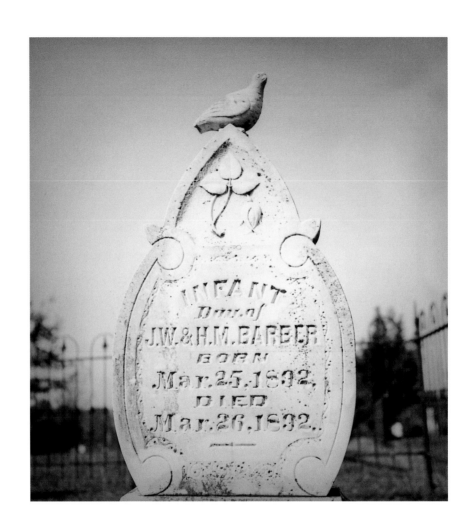

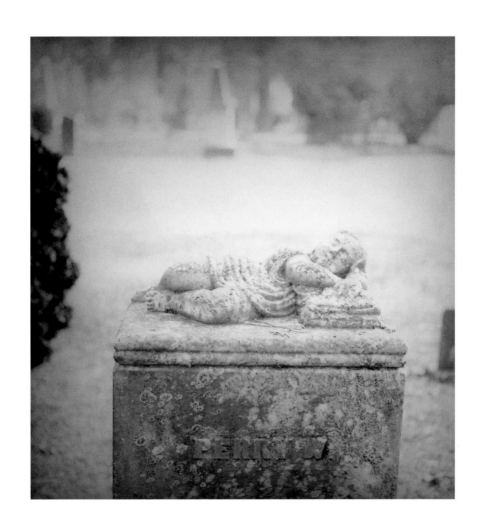

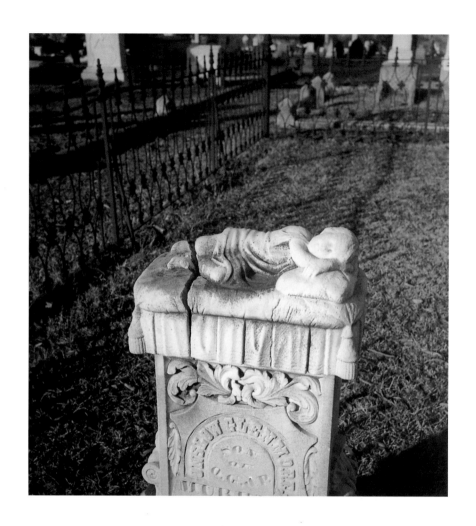

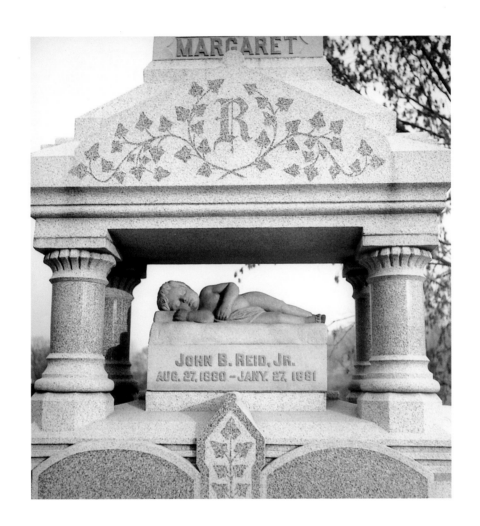

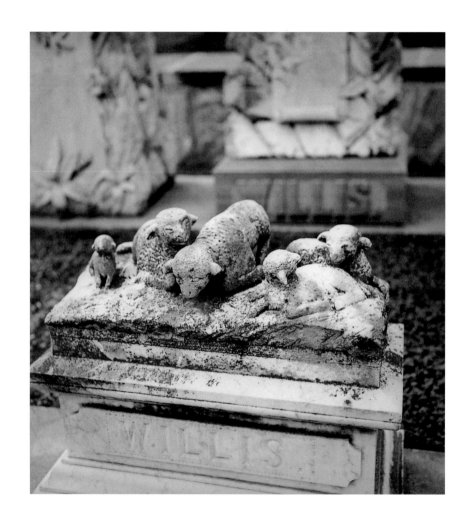

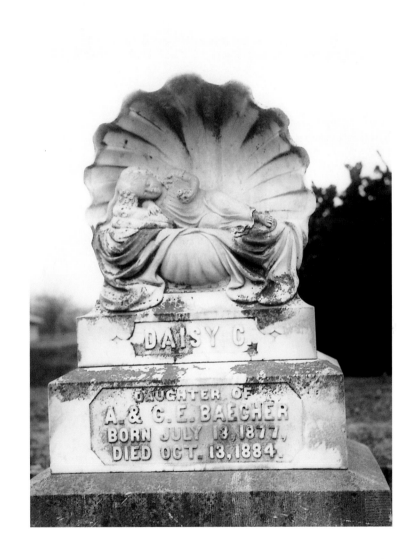

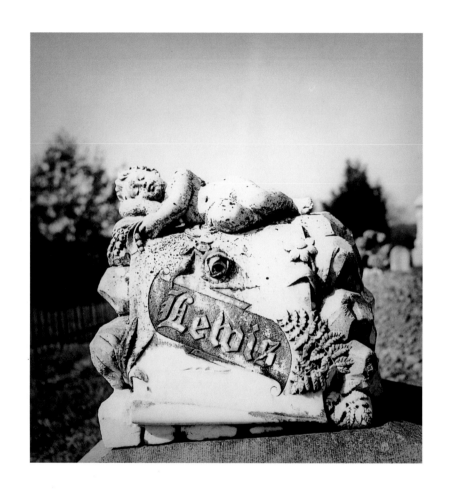

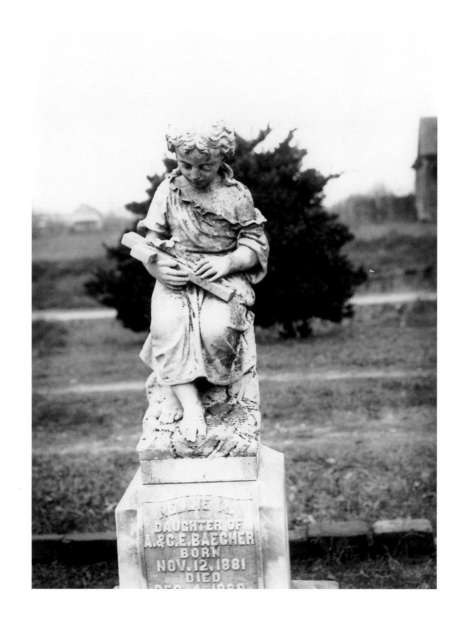

NELLIE M.
DAUGHTER OF
A. & C. E. BAECHER
BORN
NOV. 12, 1881
DIED
DEC. 4, 1886

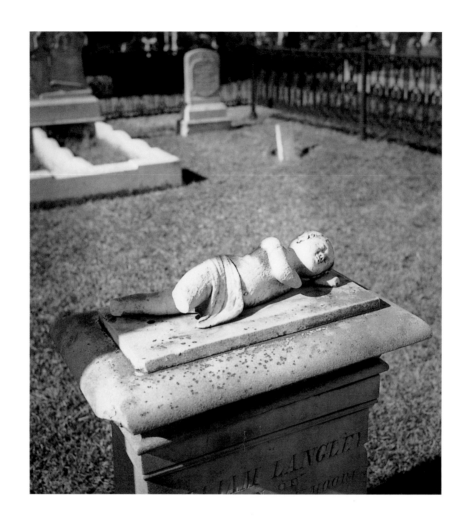